This book belongs to:

..

Dewi Lewis Publishing

allotments

Andrew Buurman

INTRODUCTION
— by —
Andrew Buurman

Allotments. There's something about the word that evokes balmy summer days spent working the land, peace and quiet, a refuge from the chaos of city life, solace achieved through honest toil and an idea that seems intangibly British.

The history of allotments is entwined with that of modern Britain. It tracks many of the major social and political changes in British life: the move away from open field agriculture; the radicalism of the Levellers and the Diggers of the English Civil War; the struggle for land that accompanied the Enclosure Acts of the 18th and 19th centuries; the population shift from countryside to town brought about by the Industrial Revolution. The late 19th century saw the introduction of new legislation establishing their status and a large expansion in number — from 244,000 in 1873 to 600,000 in 1913, just prior to the First World War.

It was during the two World Wars, however, that they became most widespread. During the First World War there were some 1.5 million allotments, with parks, private gardens and other available plots of land requisitioned for use. Popularity waned between the Wars, but by 1943 a similar number were once again in productive use. A highly successful 'Dig for Victory' campaign had encouraged the British public to make their contribution by growing food to support the home front. As part of the government propaganda several high profile sites were used; Kensington Gardens dug up its flowers and planted rows of cabbages, and the moat of The Tower of London became an allotment, as did an area of Hyde Park next to the Albert Memorial. The impact was impressive and by 1944 it is estimated that allotments and private gardens produced 10% of the food grown in the country.

After 1945 land provided temporarily for allotments was gradually returned to its previous use. Although food rationing continued until 1954, allotments became less popular. Their association with war-time austerity, the increasing affluence of the UK population and a significant

reduction in available land were all key factors. By the 1990s numbers were back to what they had been a century earlier. Today there has been a minor resurgence, due at least in part to our increased awareness of green issues. There are now some 300,000 allotments in the UK often shared between families and friends and waiting lists are long. Yet the pressure on available land means that in most urban environments there is little potential for new sites.

This project began when my cousin, Stephen, chairman of an allotment society in Liverpool, suggested that I take some photographs there. In the course of an afternoon spent drinking tea and chatting to members, I realised that photographing something as specific as allotments might allow reflection on something much broader: on changing ideas of Britishness, cultivation and culture.

These photographs were all taken on Uplands Allotments, in Handsworth in the heart of Birmingham. Choosing one location allowed me to both build relationships with the people and document the passing seasons. Uplands – with 422 plots – is the largest allotment site in the UK. Opened in 1949, with its own allotment office and meeting hall, it still retains much of the communal spirit of the post-war era with weekly tea dances and bingo nights as well as an annual flower and vegetable show.

The area is one of the most multicultural in the UK and this is reflected in the diversity of the plot holders with more than a dozen nationalities represented. As I walked around the plots it was possible to guess at the ethnic background of the grower with some accuracy, not just by what they were growing but also by how they were growing it. The 'English' allotment was laid out in ordered rows: a row of carrots here, a row of lettuce there and very much the classic kitchen garden. Those with an Asian background used the land as a small field with profusions of aromatic coriander and methi, sometimes growing just four separate crops on the plot. Meanwhile those with a Caribbean background would frequently use their plot more as a 'yard', with thyme, pumpkins and sometimes ackee grown in patches. Although this was a pattern rather than a rule, what struck me was that, in their use of the plot, each culture was adding something unique transforming the gardens into a visual patchwork of contemporary Britain. The concept of the allotment was evolving – organically – and this seemed entirely natural in all senses of the word.

These humble patches of earth are much valued by those who work them. The benefits of fresh air, exercise, eating fresh food and the satisfaction of literally seeing the fruits of one's labour seem obvious. Equally important though is that allotments also offer a retreat, a place of peace, of escape from work, home, spouse, the pressures of daily life and a sense of camaraderie that unites diverse social and ethnic groups. Often during the project, at moments I felt under pressure, my wife would suggest I should take myself off to the allotments in urban Birmingham – a place where the birdsong was so loud and the traffic so quiet.

Whenever I mentioned the work to friends the response was warm and positive – for many it brought to mind images of fertile oases amongst the city sprawl or reminiscences of older family members retreating to the tranquility of an urban countryside. But the affection in which allotments are held nationally isn't just the result of history or familiarity. Propagandists and politicians, of all hues, have long exploited the myth of England's 'green and pleasant land' – the more bucolic view of the English condition – as a rallying cry to deep-rooted values. The reality is that most of us live in urban areas. However, even if this search for a pastoral idyll lacks direct relevance and is not a true reflection of reality, there seems no reason why it shouldn't remain as an ideal – perhaps an important one in a nation of city dwellers.

Throughout their history, allotments have been promoted by both radicals and conservatives, and have served the interests of both equally. Today a gently weathered motto greets visitors at the entrance to Uplands Allotments. No one I asked seemed to know if its origins were biblical or political but it seems apposite. 'By the toil of each, and the fellowship of people all good things will happen.'

— AB —

For Neila and Maya

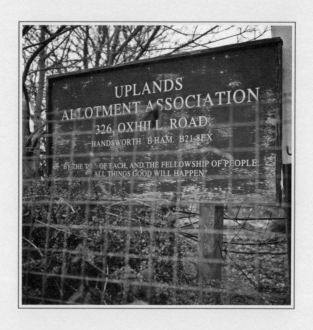

— 01 —

We go, in winter's biting wind,
On many a short-lived winter day,
With aching back but willing mind
To dig and double dig the clay.

Ruth Pitter
The Diehards

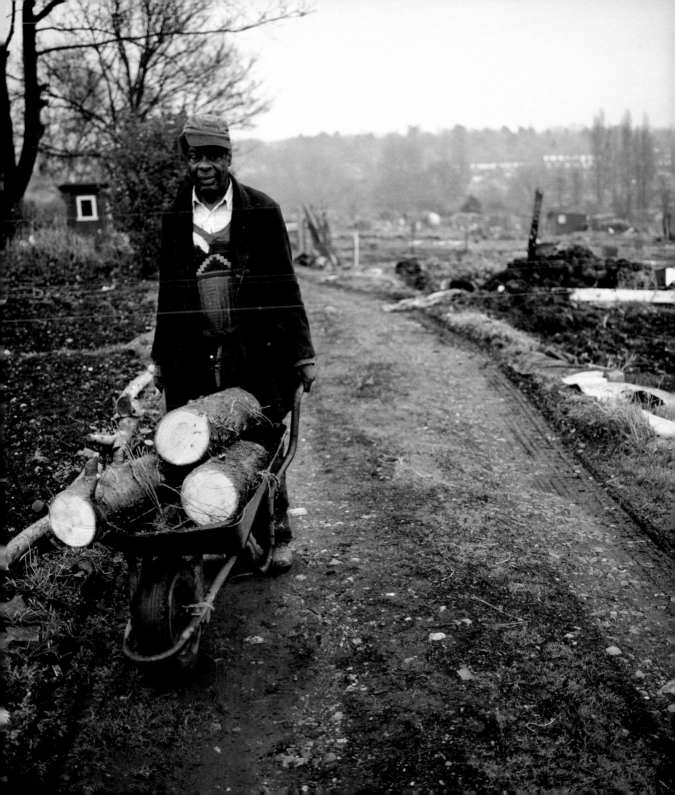

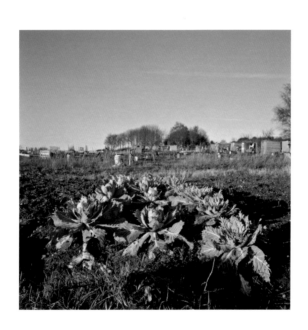

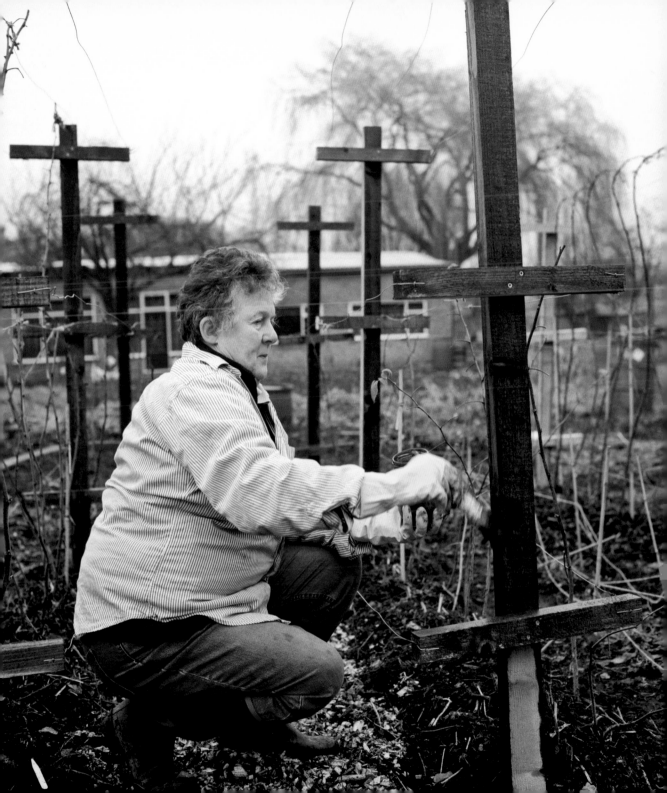

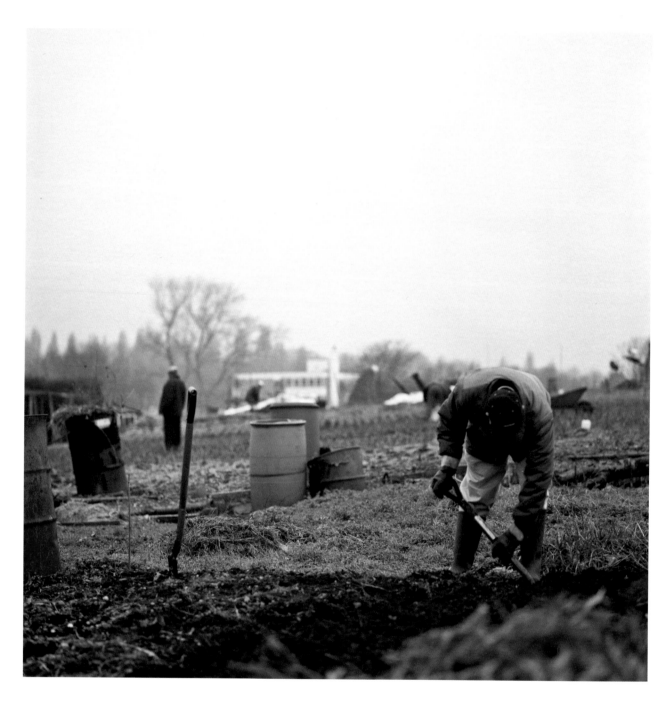

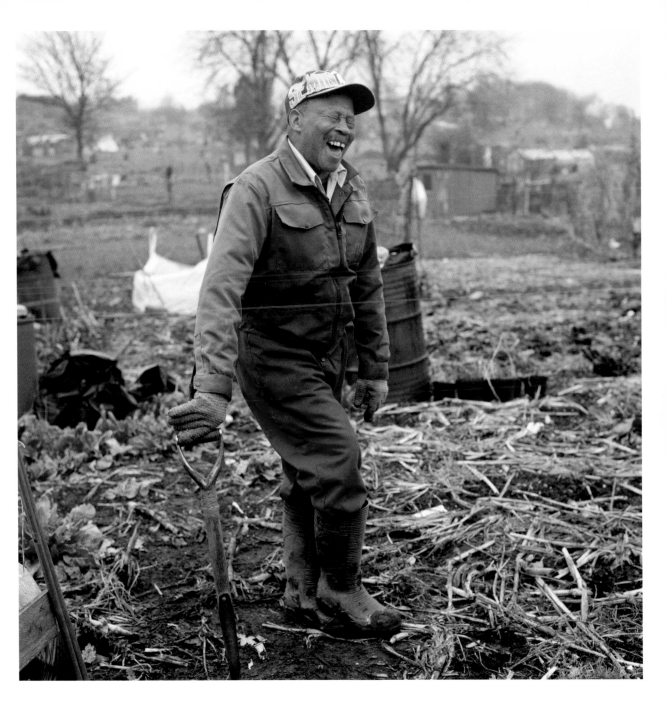

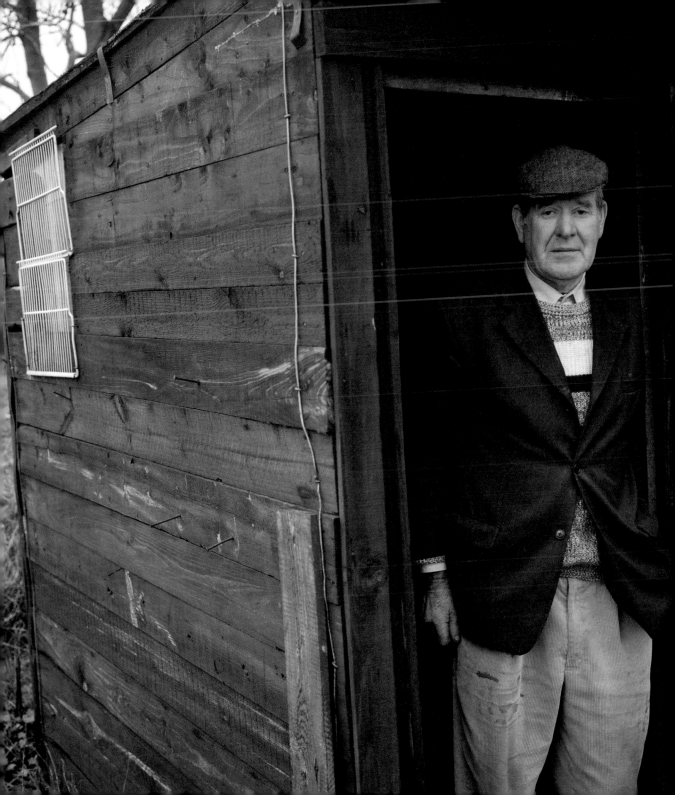

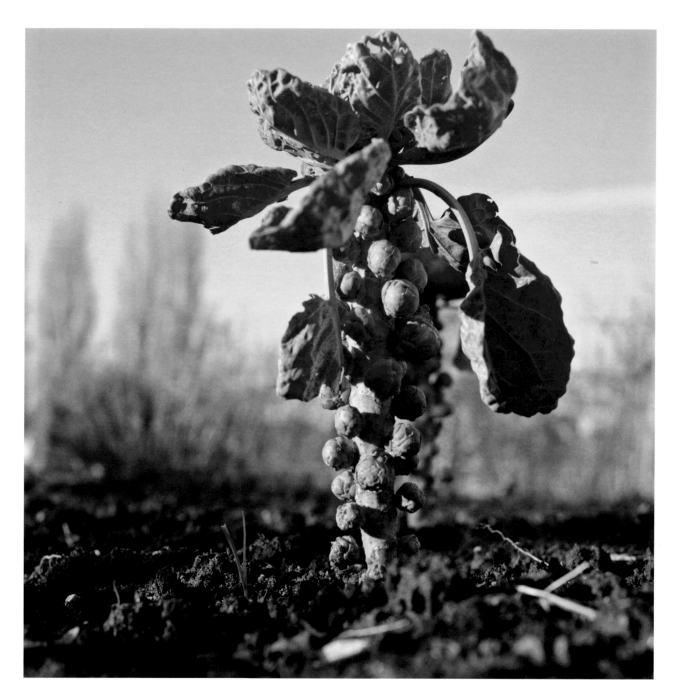

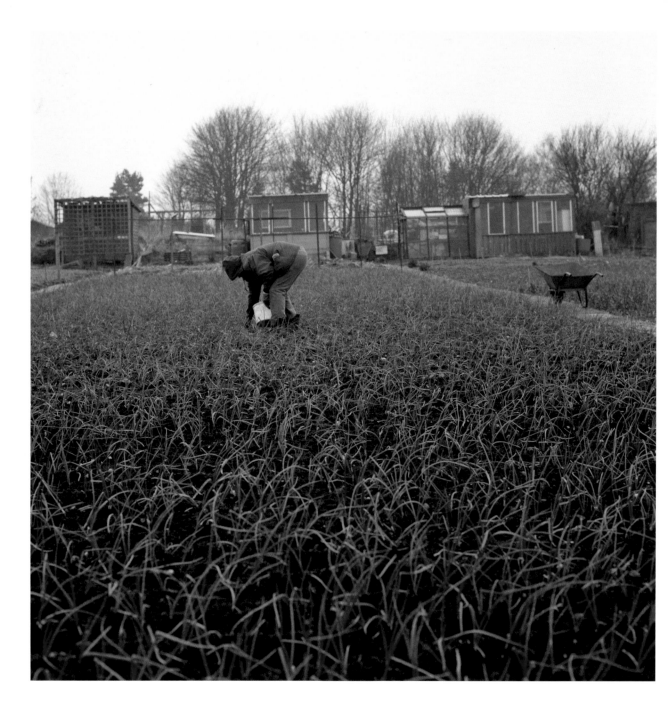

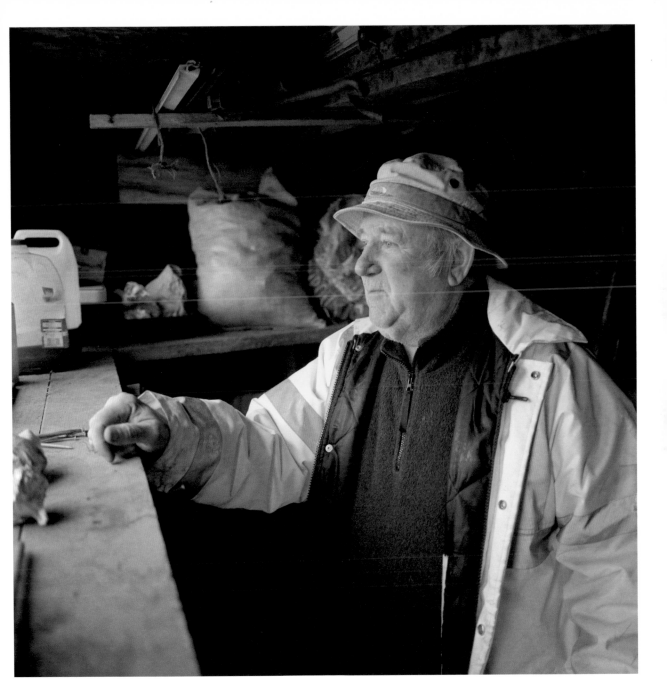

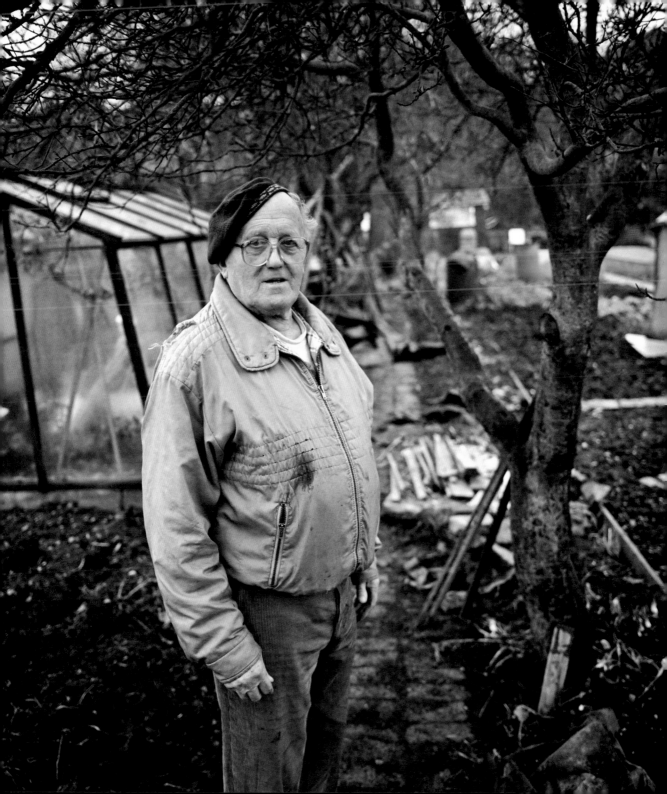

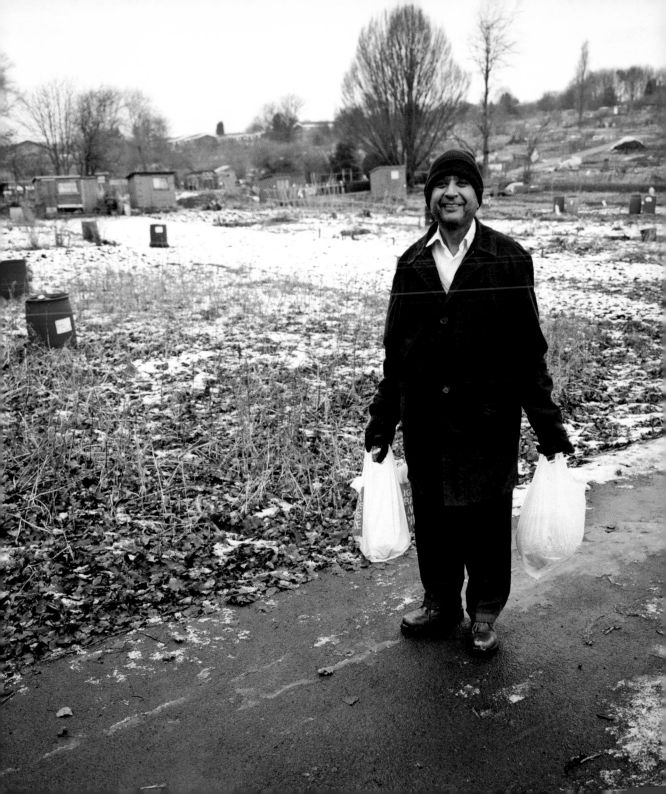

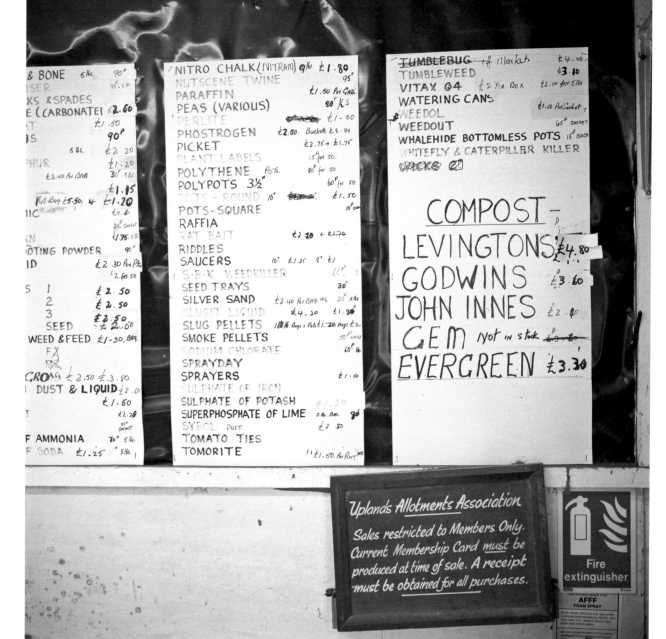

Left list (partially cut off)

& BONE 5kc 90p
...ISER 90p 5kc
...KS & SPADES
...E (CARBONATE) £2.60
...T £1.50
...S 90p
5 lbs. £2.20
...PHUR £1.20
£2.40 Per BAG 30p 5lbs
£1.15
Full Bag £5.50 4 £1.20
...IC £4.60
28p Sachet
£1.75 5lbs
...RN
...OTING POWDER 90p
...D £2.30 Per Pt
£2.60.50
...S 1 £2.50
2 £2.50
3 £2.50
SEED £2.00
...WEED & FEED £1-30. BAG.
FX
NX
...GRO £2.50 £3.80
...DUST & LIQUID £2.60
£1.50
£2.20
21p SACHET
...F AMMONIA 70p 5lbs
...F SODA £1.25 5lbs

Middle list

NITRO CHALK (NITRAM) 9/kc £1.80
NUTSCENE TWINE 95p
PARAFFIN £1.50 Per Gall
PEAS (VARIOUS) 80p Kg
PERLITE £1.00
PHOSTROGEN £2.00 Buckets £8.99
PICKET £2.75 + £1.75
PLANT LABELS 65p for 50
POLYTHENE Pots. 80p for 50
POLYPOTS 3½" 60p for 50
POTS - ROUND 10" £1.50
POTS - SQUARE 10p each
RAFFIA
RAT BAIT £2.70 + £1.70
RIDDLES
SAUCERS 10" £1.25 8" £1
S·B·K WEEDKILLER
SEED TRAYS 30p
SILVER SAND £2.40 Per Bag As. 25p 5lbs
SLUGIT LIQUID £4.20 £1.80
SLUG PELLETS
SMOKE PELLETS 50p each
SODIUM CHLORATE 60p lb.
SPRAYDAY
SPRAYERS £1.50
SULPHATE OF IRON
SULPHATE OF POTASH £1.20
SUPERPHOSPHATE OF LIME 5lb Bag 90p
SYBOL DUST £2.80
TOMATO TIES
TOMORITE £1.50 Per Pint

Right list

TUMBLEBUG at Market £4.00
TUMBLEWEED £3.70
VITAX Q4 £2 Per Box £2.00 for 5lbs
WATERING CANS £1.10 Per Sachet
WEEDOL
WEEDOUT 65p Sachet
WHALEHIDE BOTTOMLESS POTS 15p each
WHITEFLY & CATERPILLAR KILLER
PACKS £2

COMPOST -
LEVINGTONS £4.80
GODWINS £3.60
JOHN INNES £2.40
GEM Not in stock
EVERGREEN £3.30

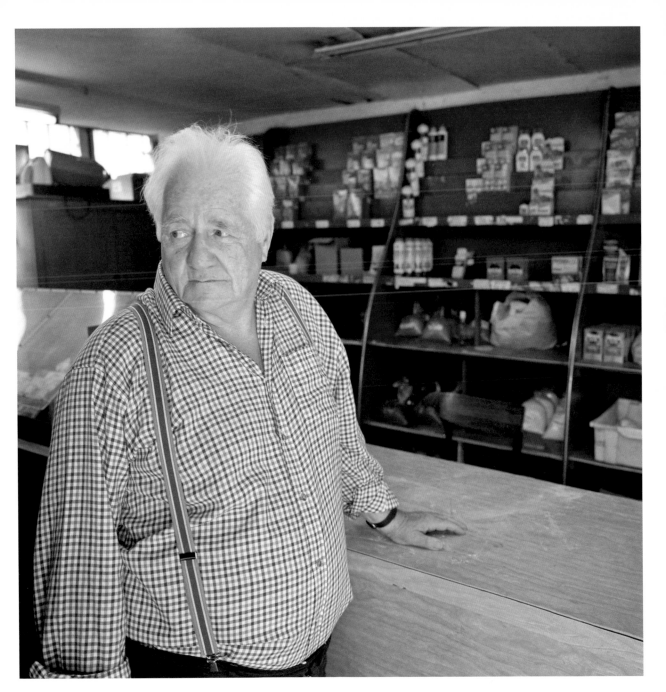

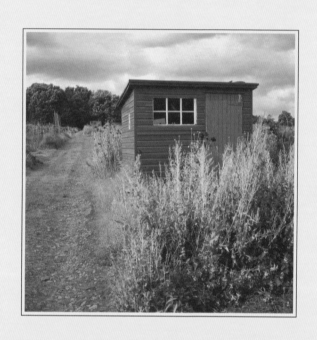

— 02 —

And Spring arose on the garden fair,
like the Spirit of Love felt everywhere;
And each flower and herb on Earth's dark breast
rose from the dreams of its wintry rest.

Percy Bysshe Shelley
The Sensitive Plant

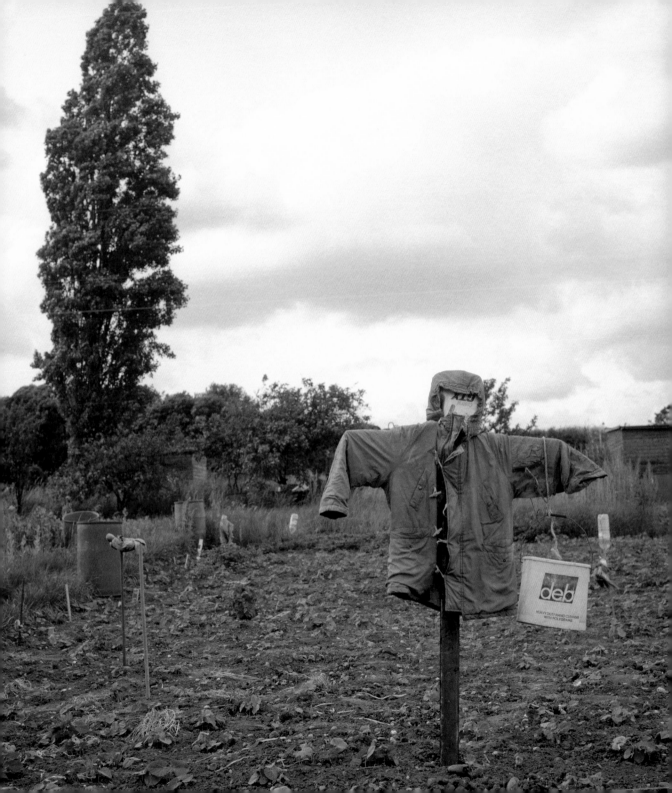

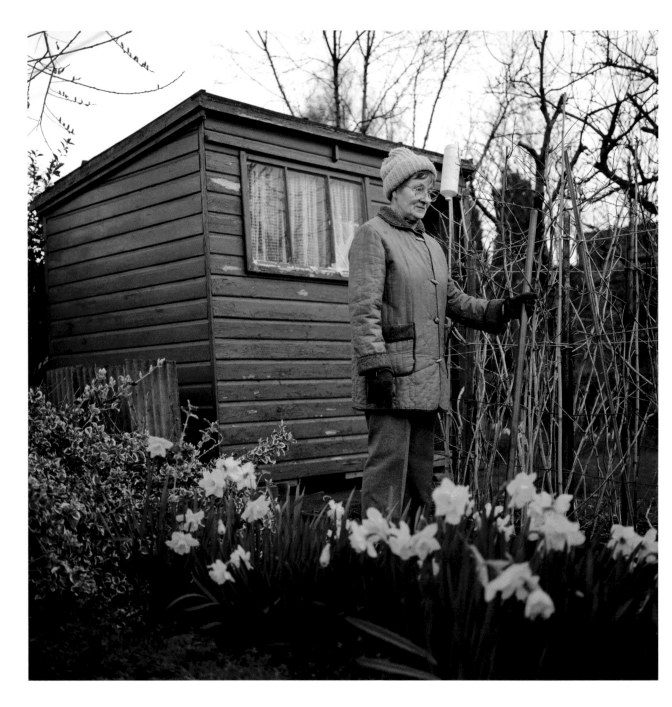

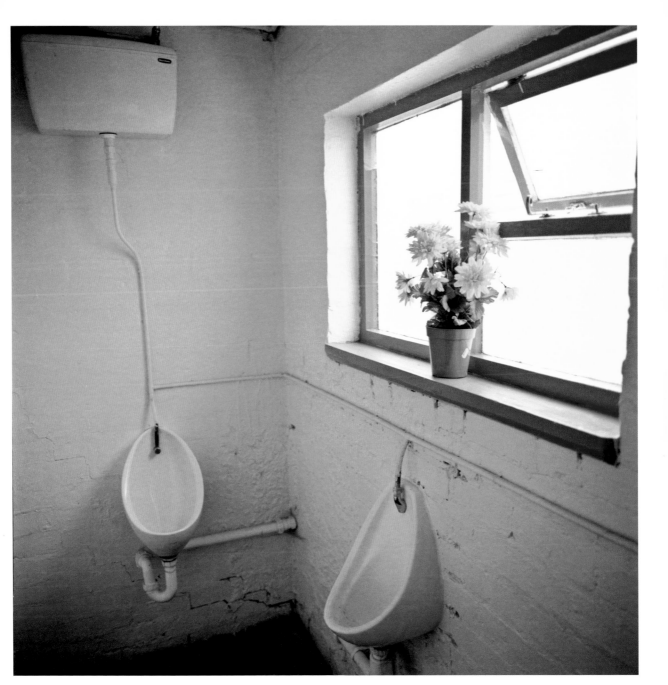

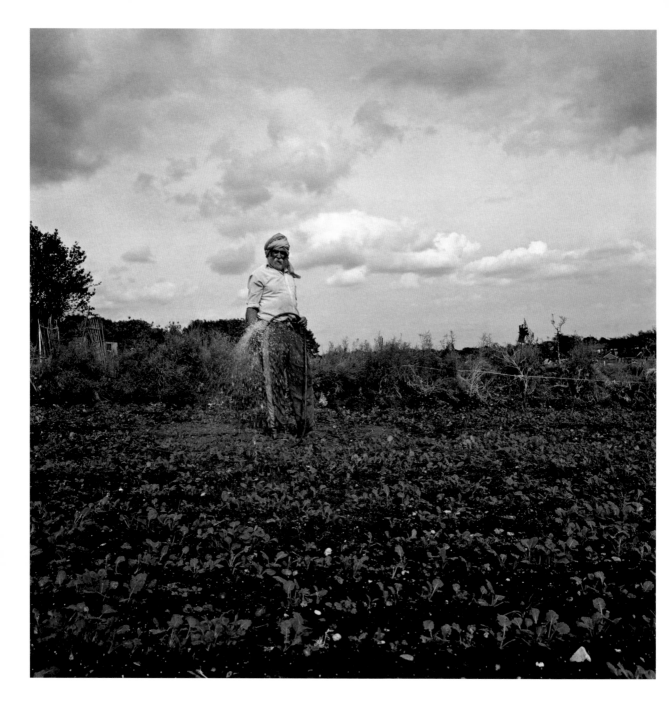

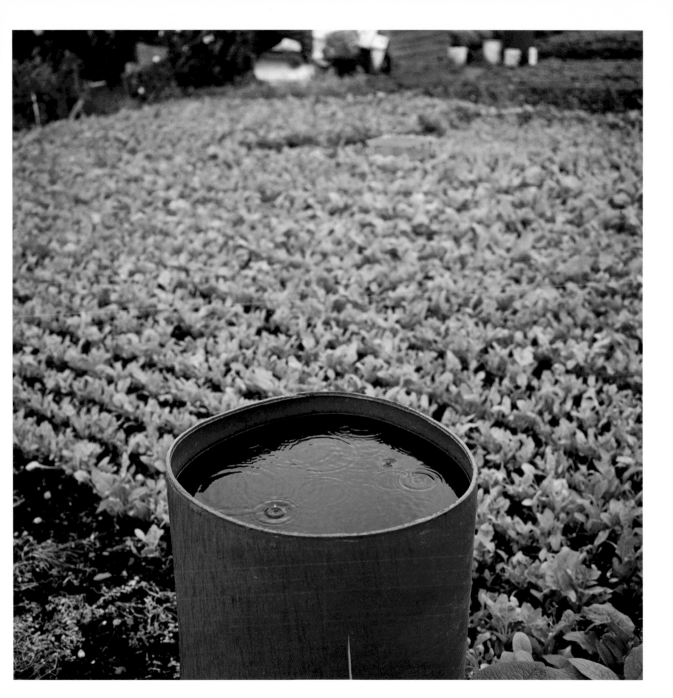

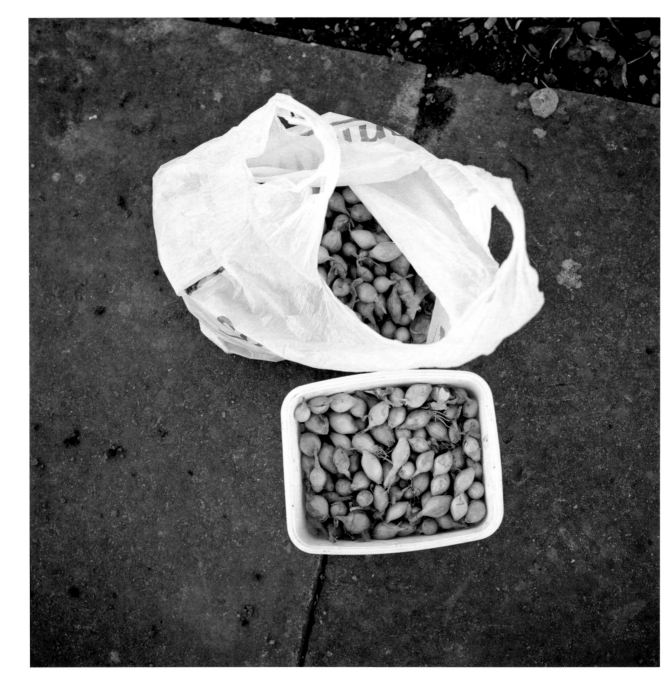

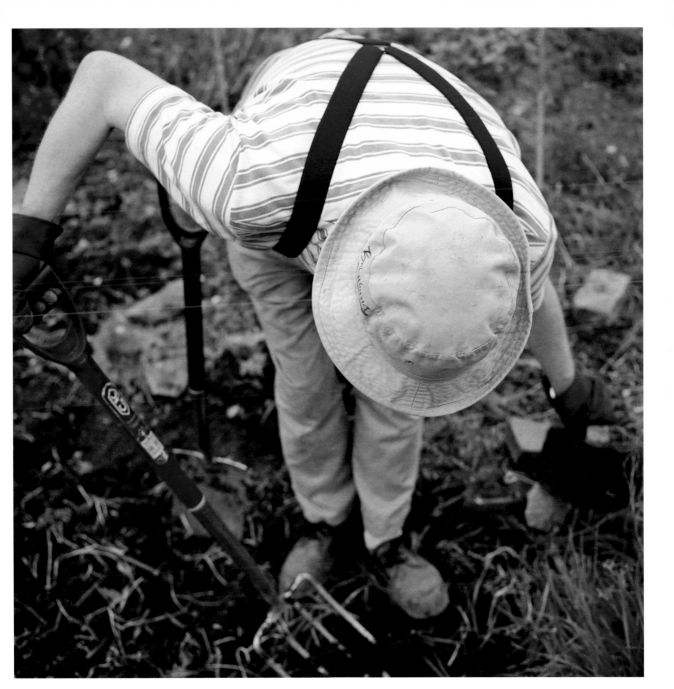

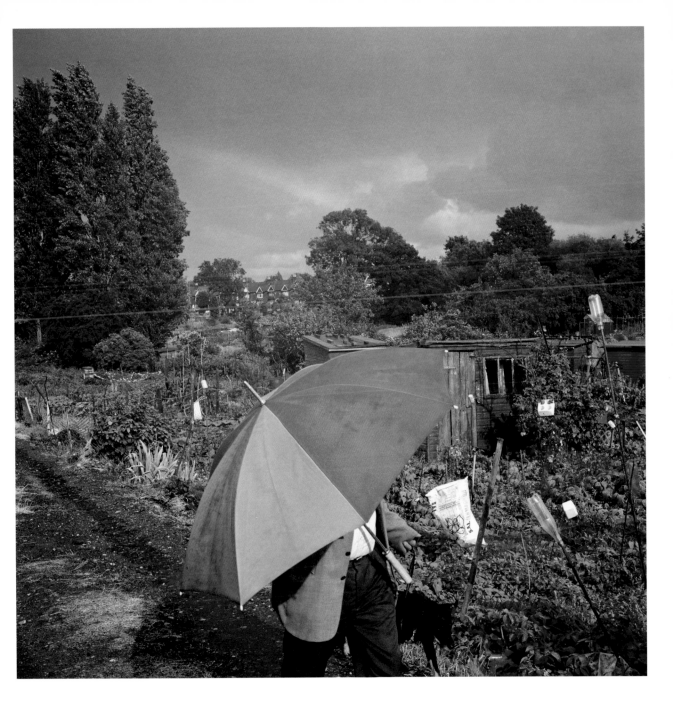

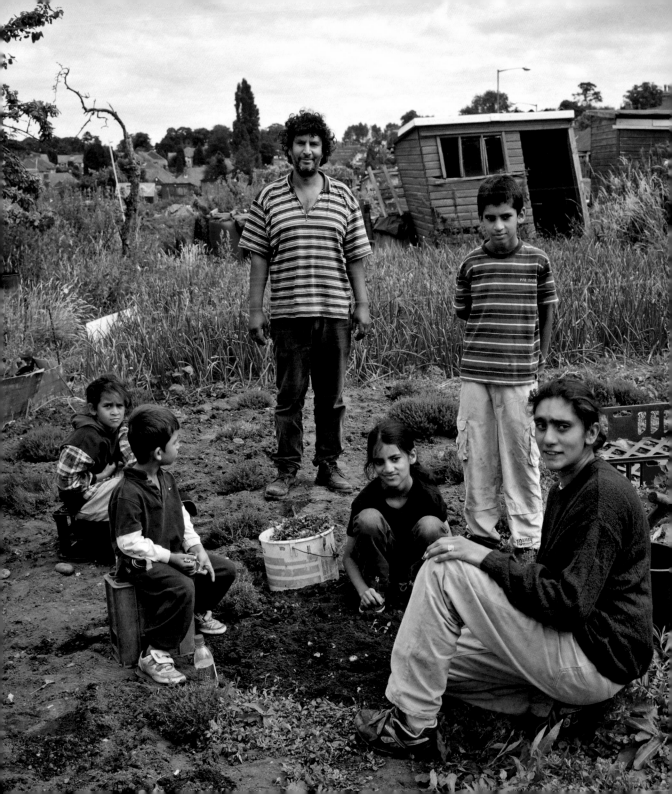

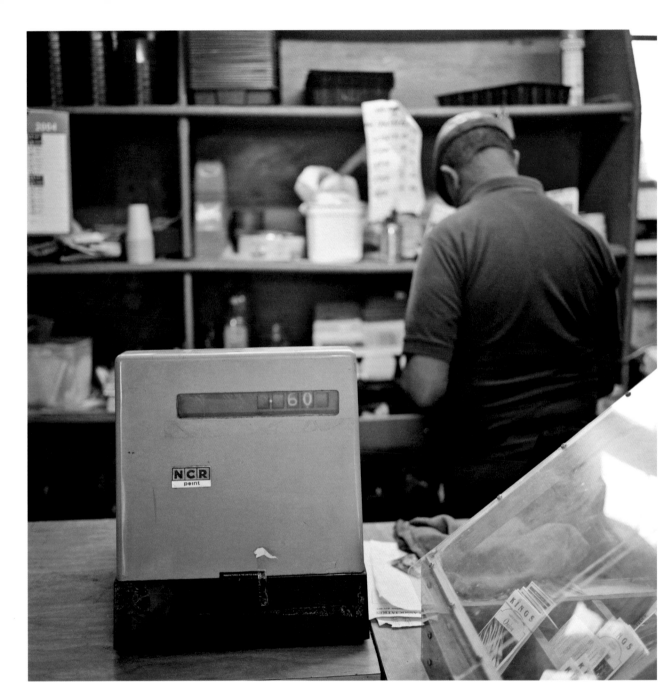

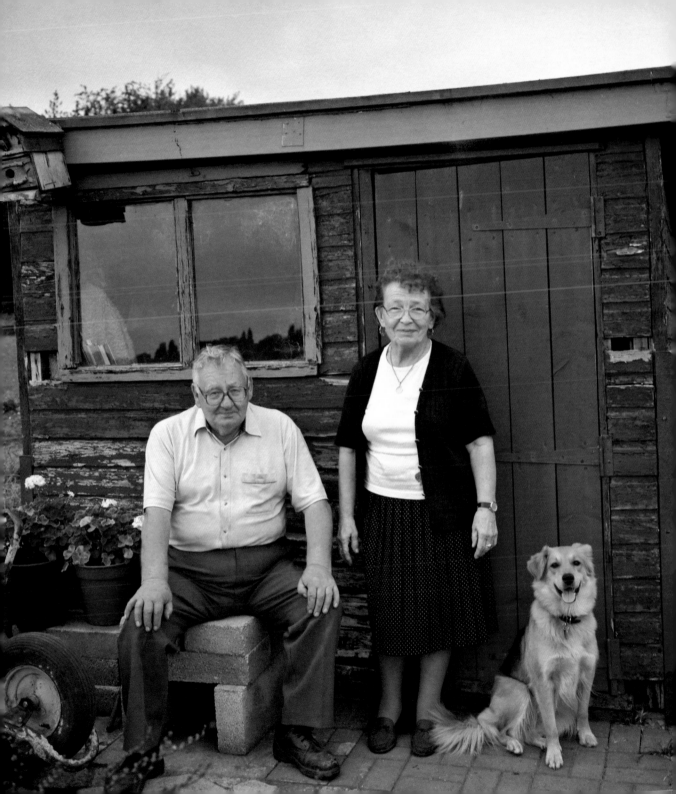

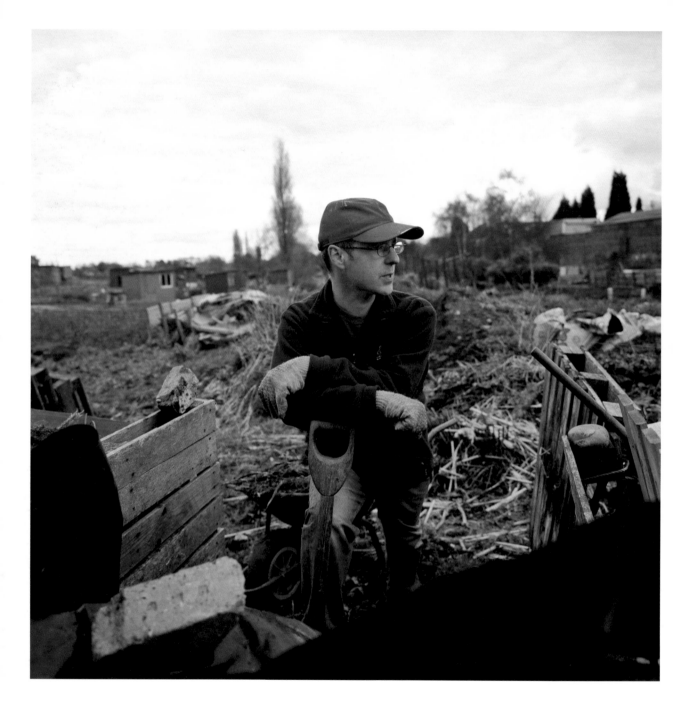

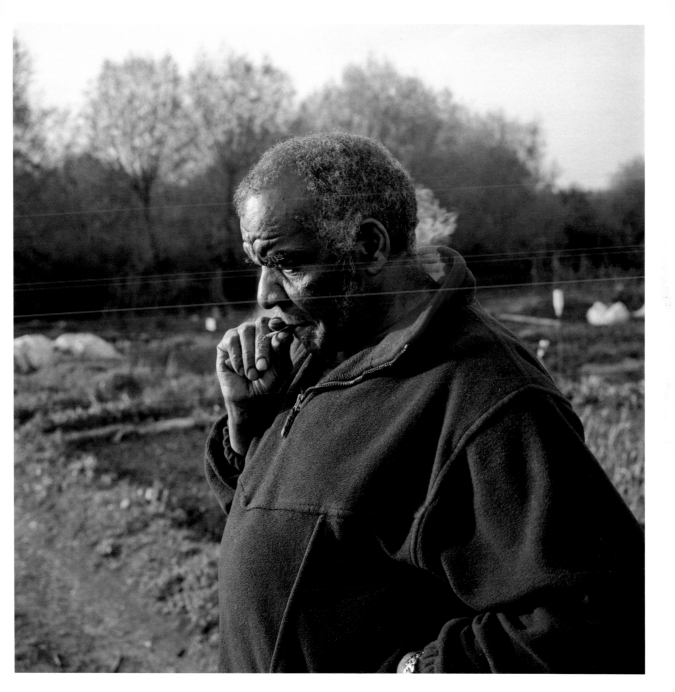

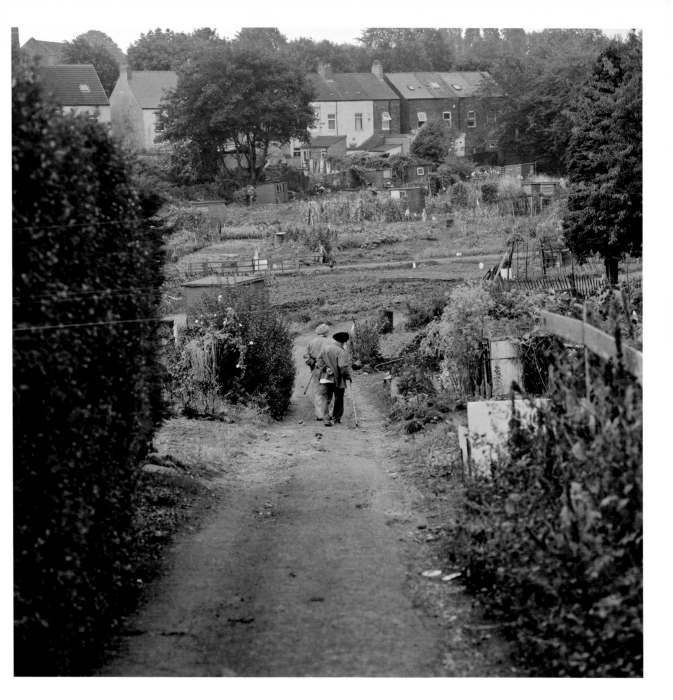

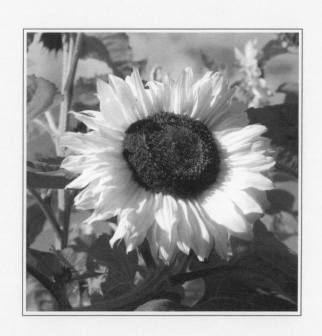

— 03 —

Summer afternoon—summer afternoon;
to me those have always been the
two most beautiful words in
the English language.

Henry James
Edith Wharton's *A Backward Glance*

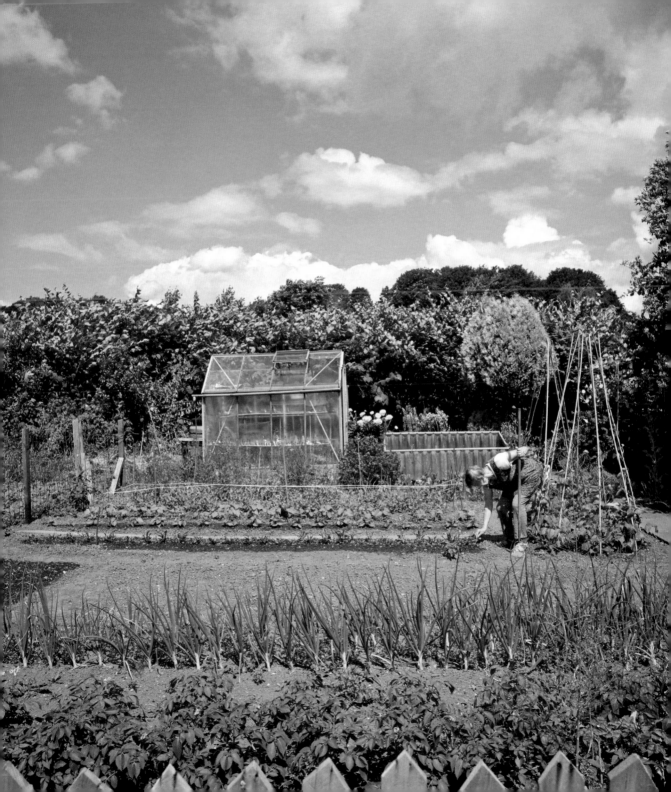

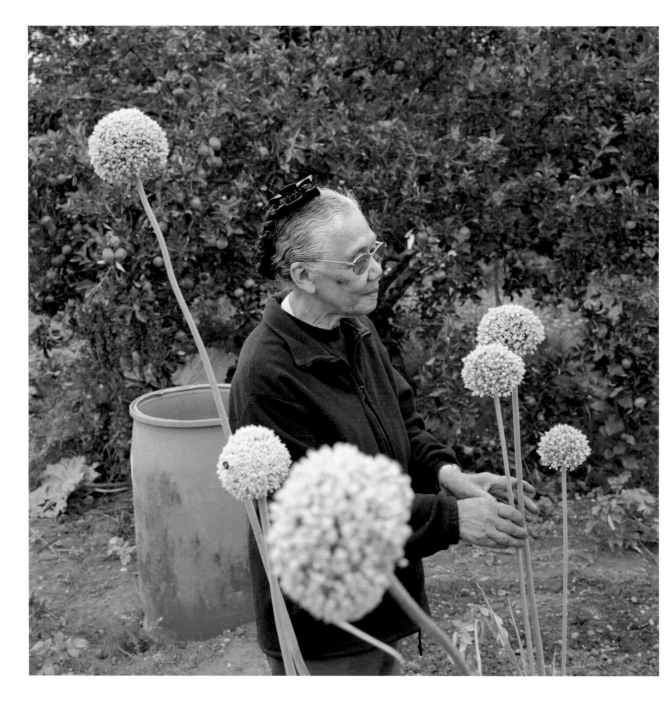

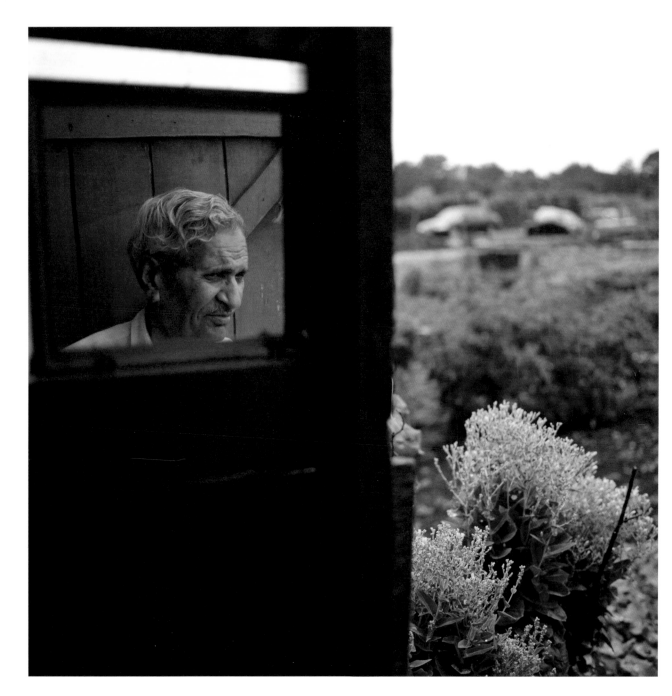

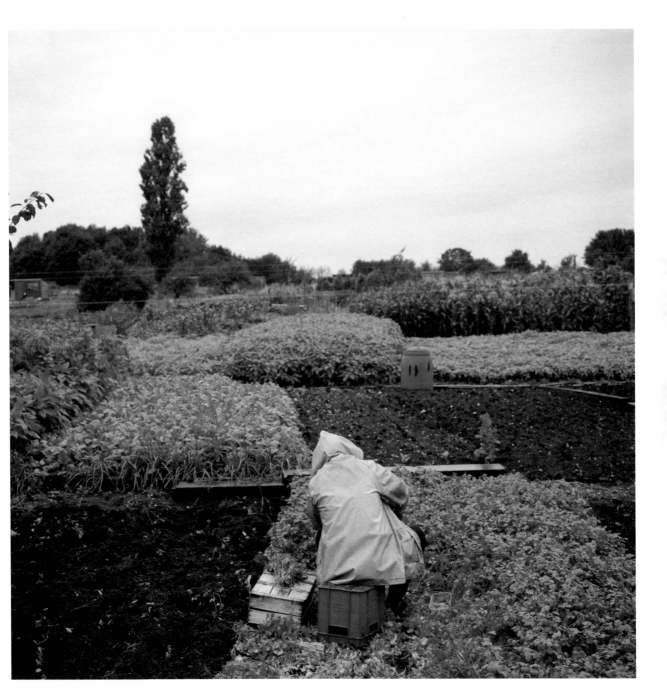

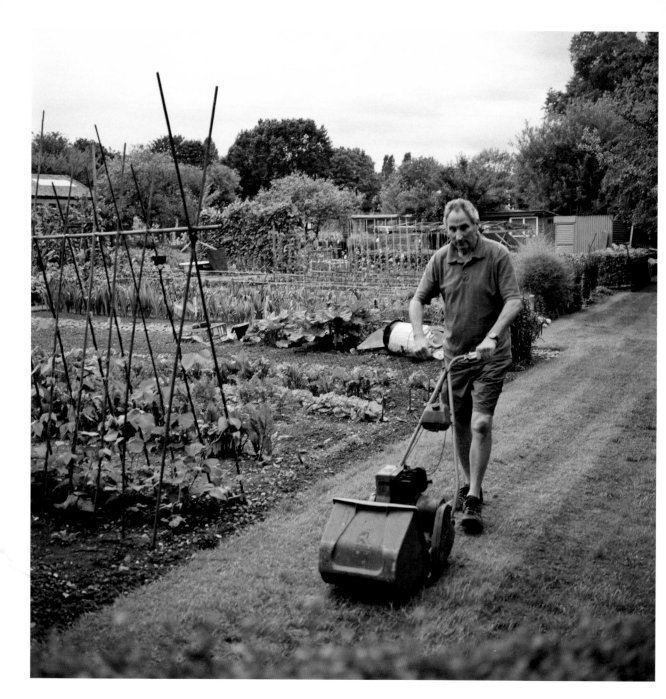

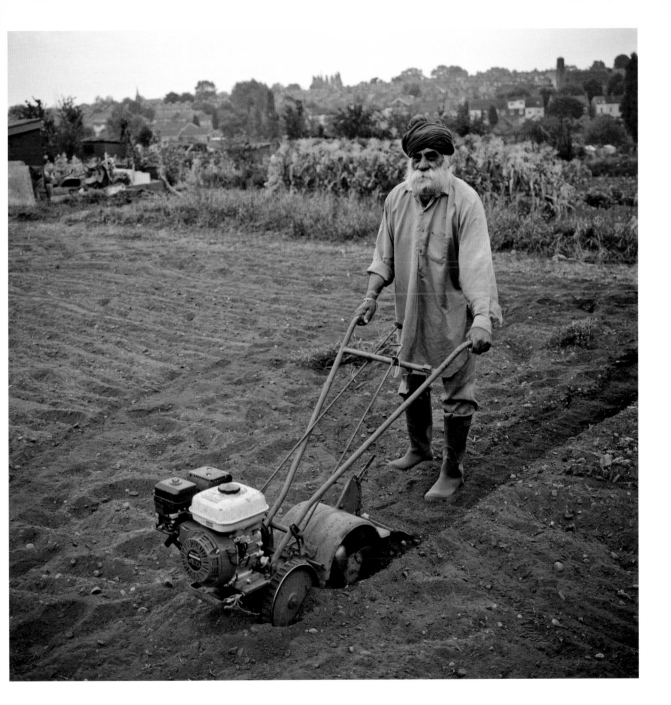

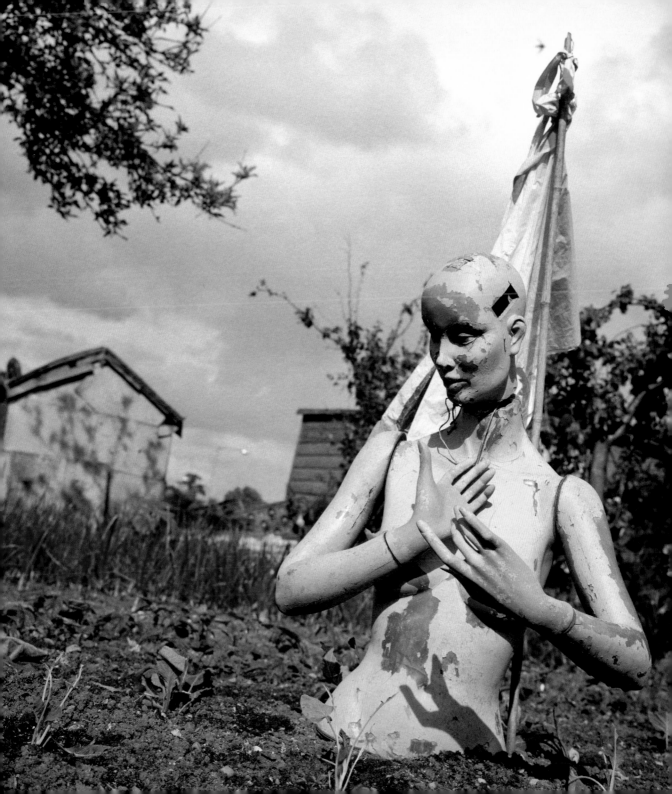

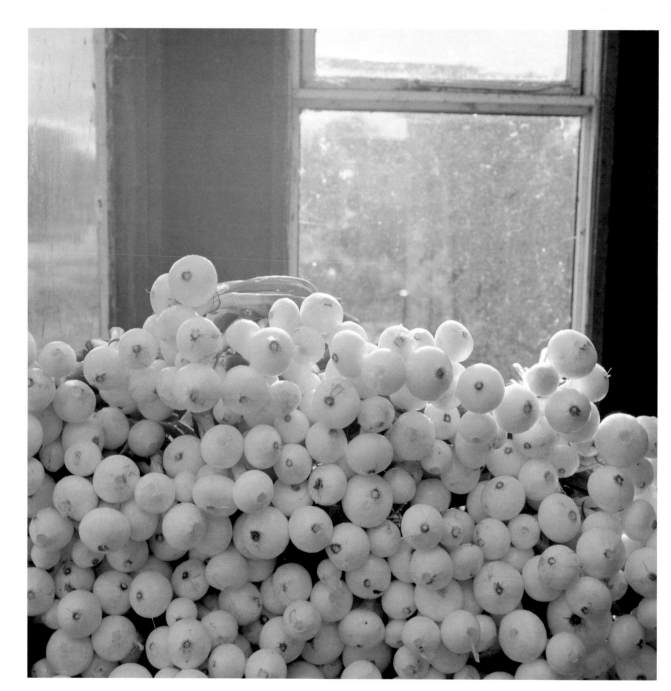

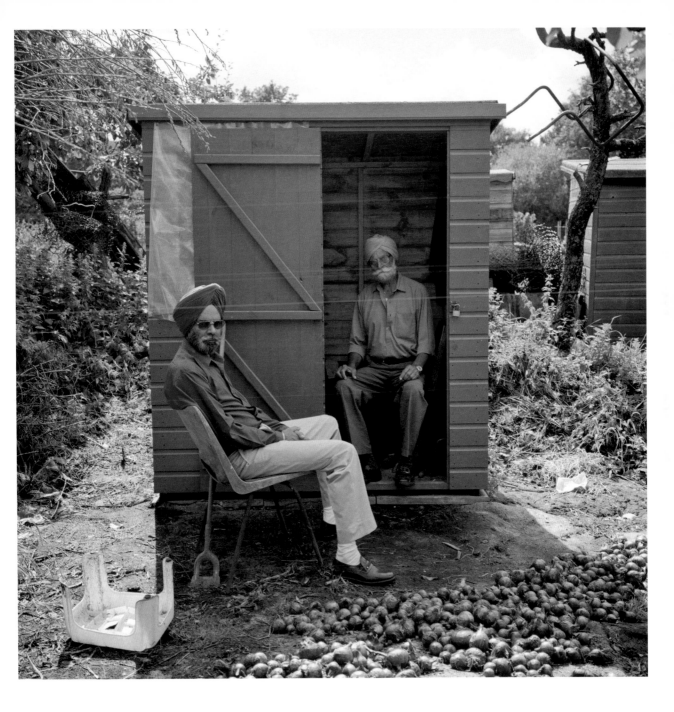

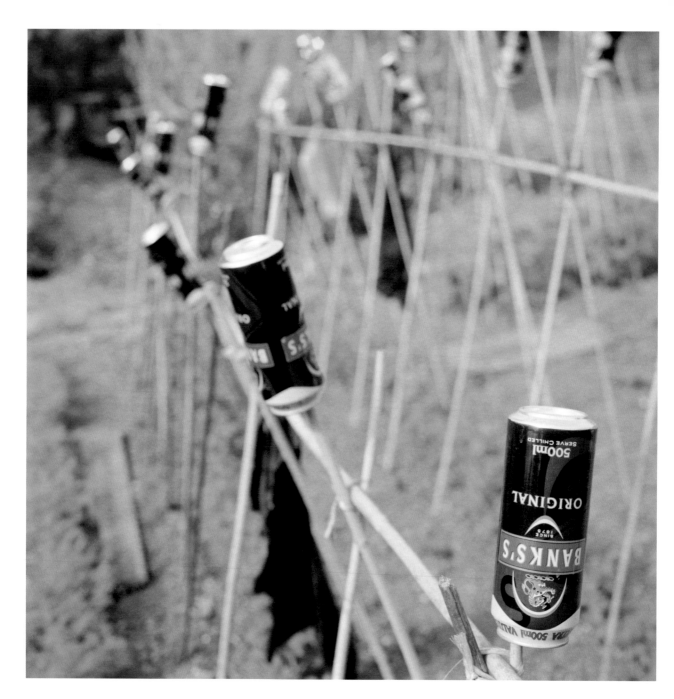

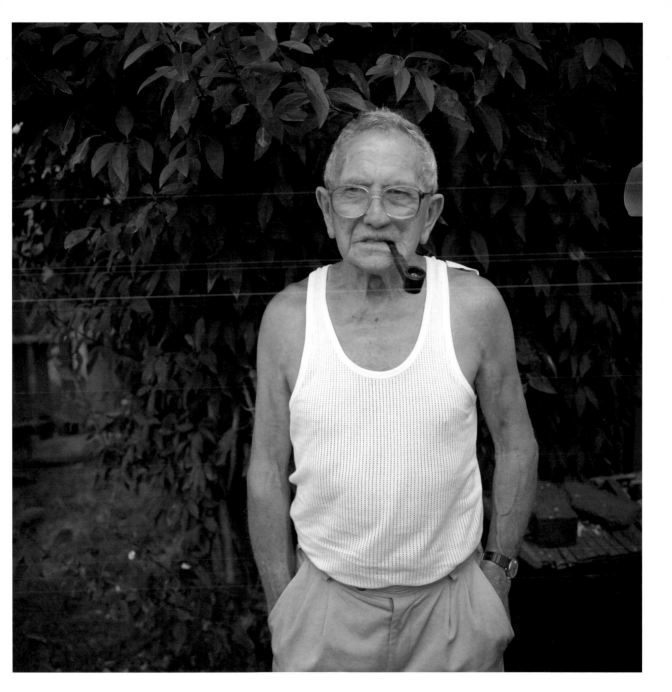

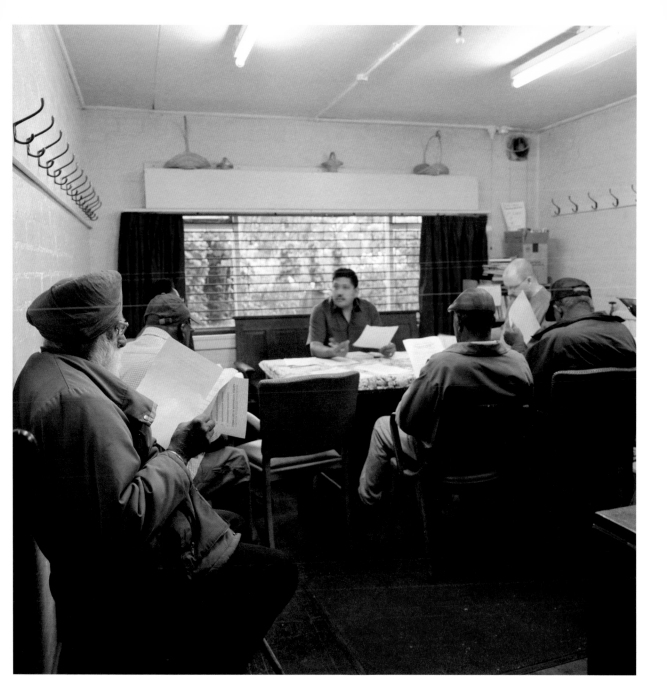

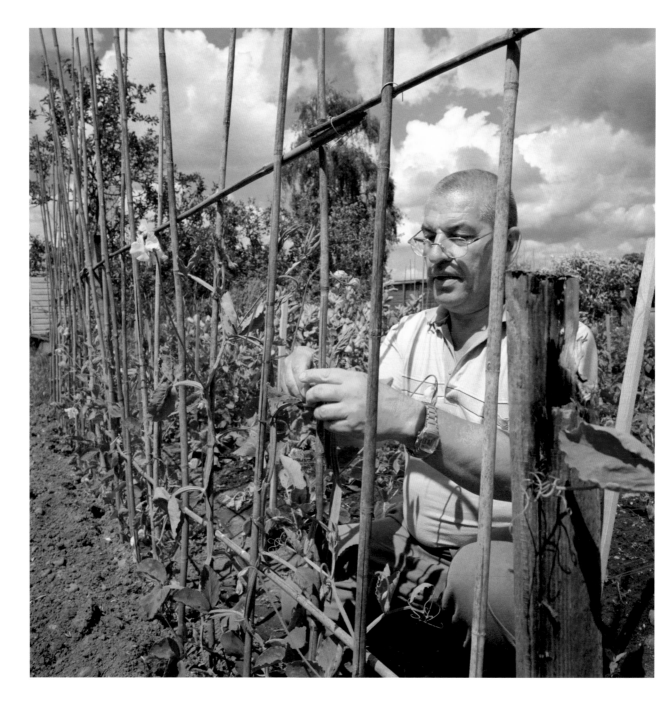

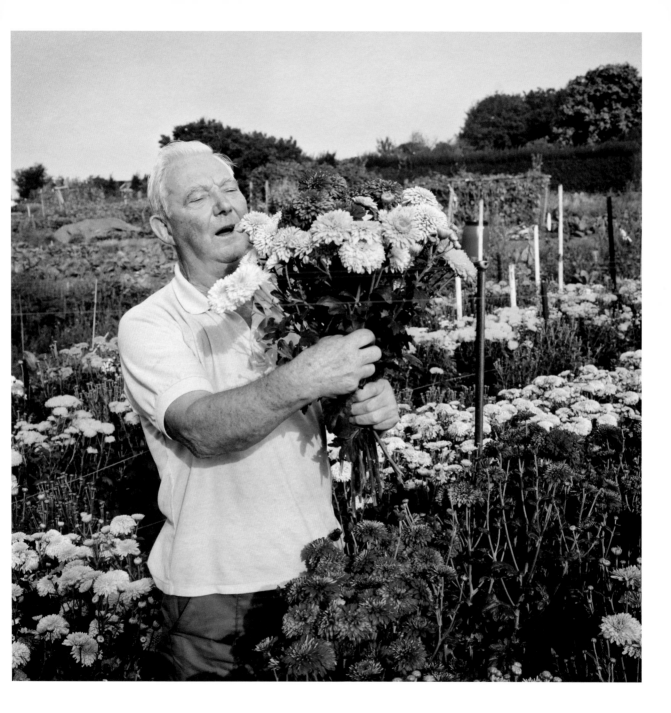

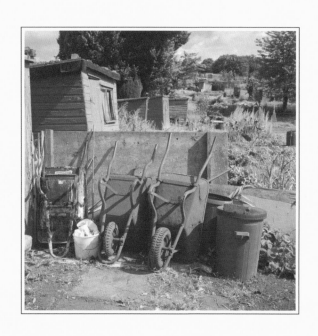

— 04 —

It was one of those perfect
English autumnal days
which occur more frequently
in memory than in life.

P.D James
~

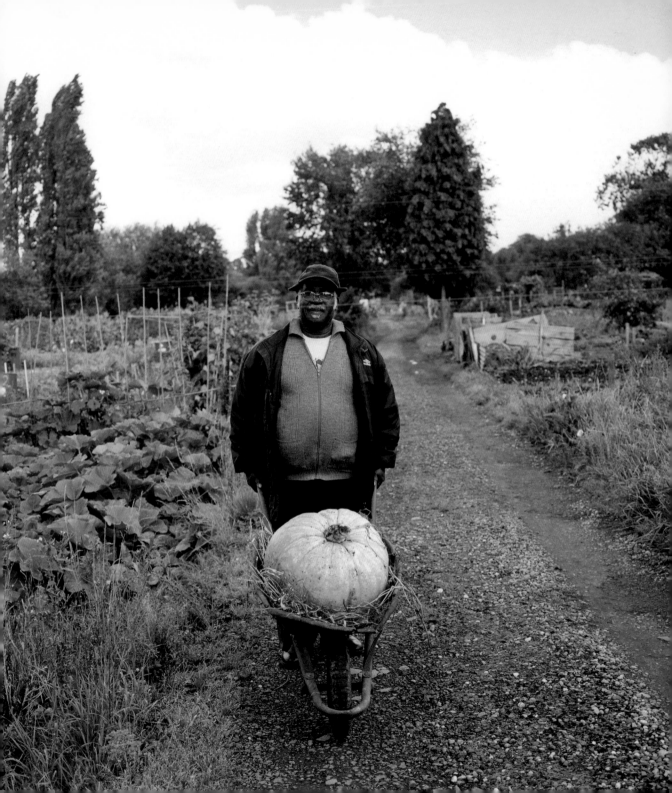

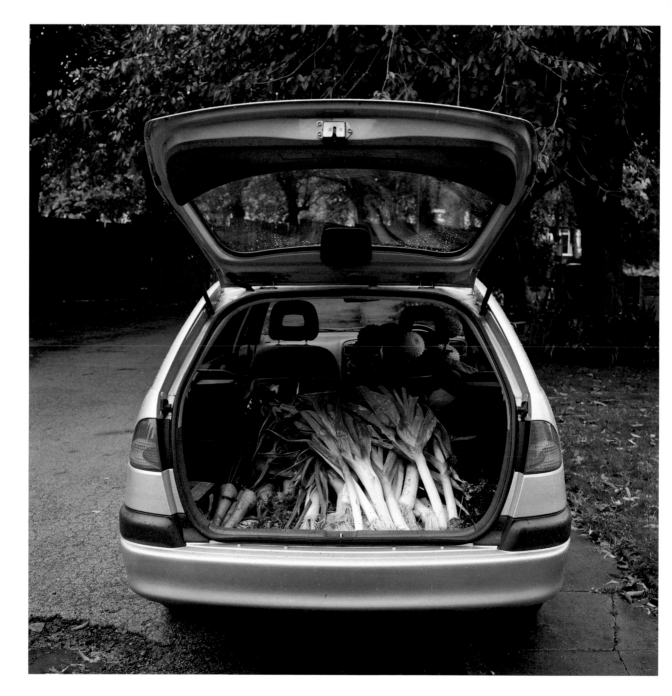

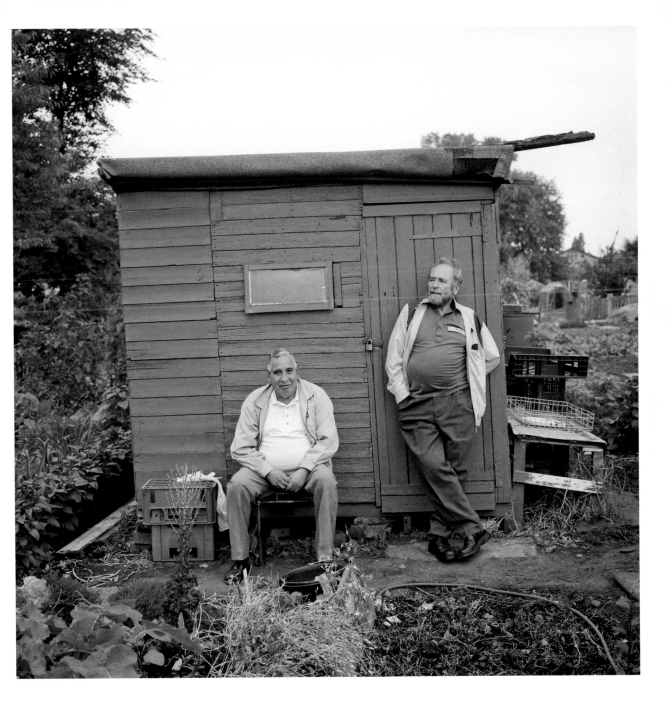

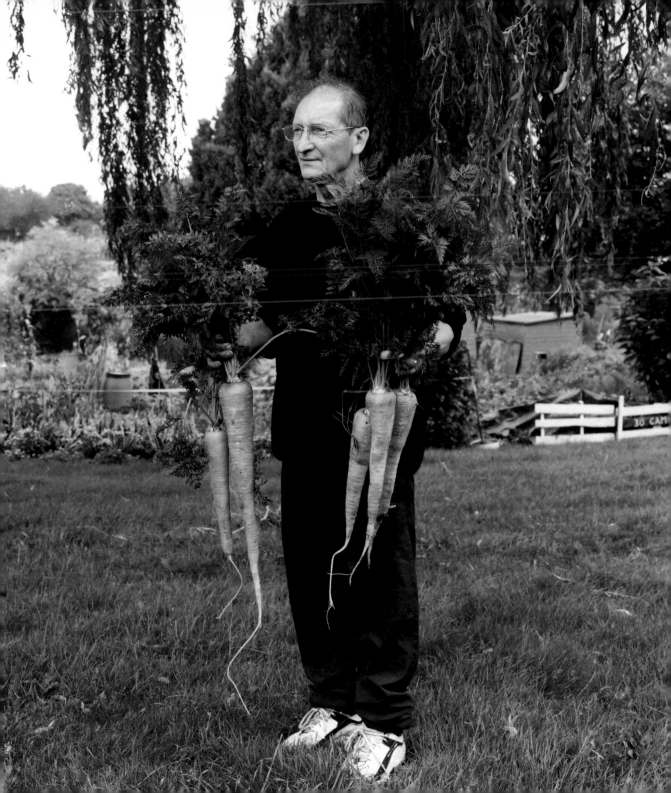

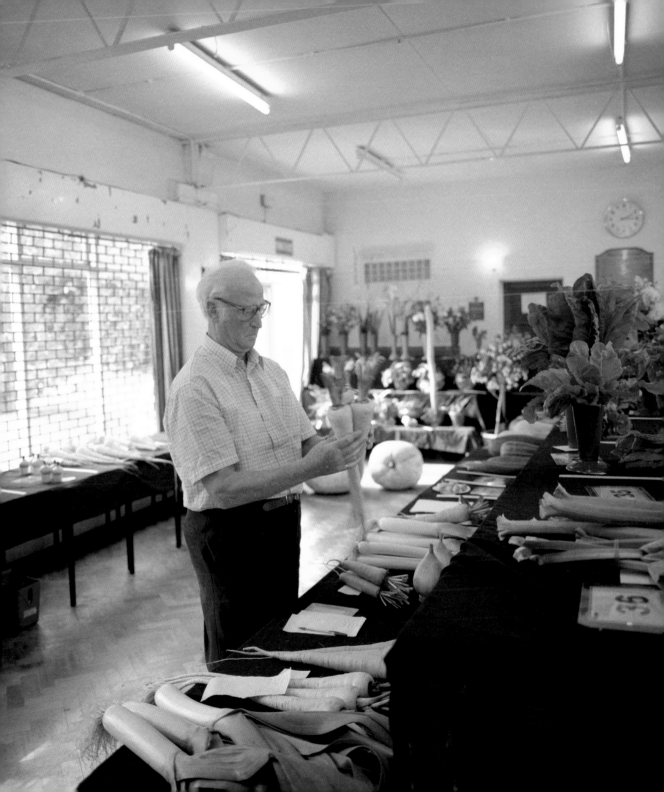

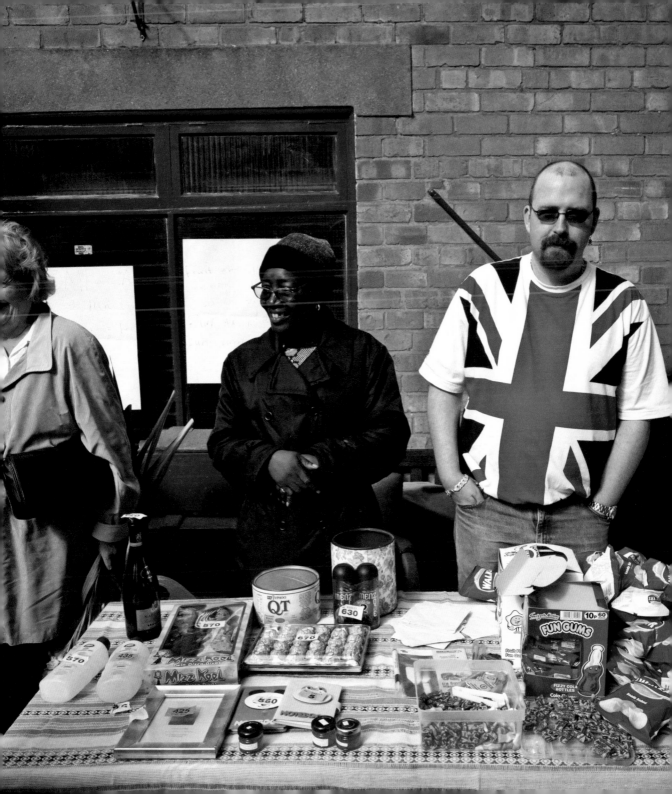

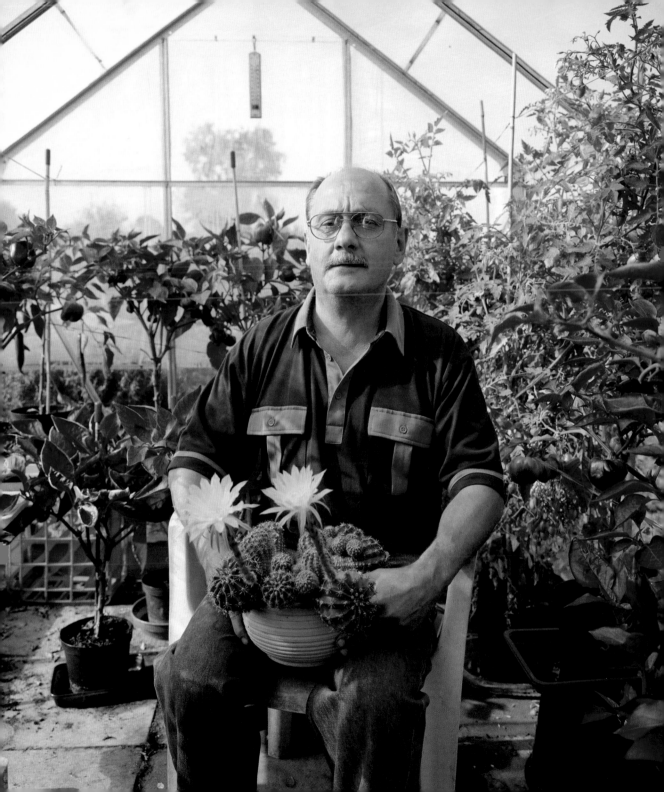

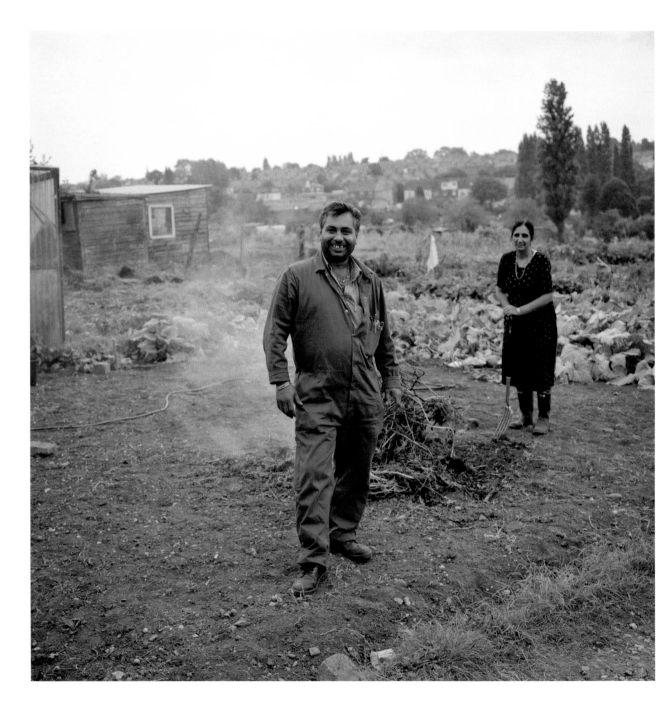

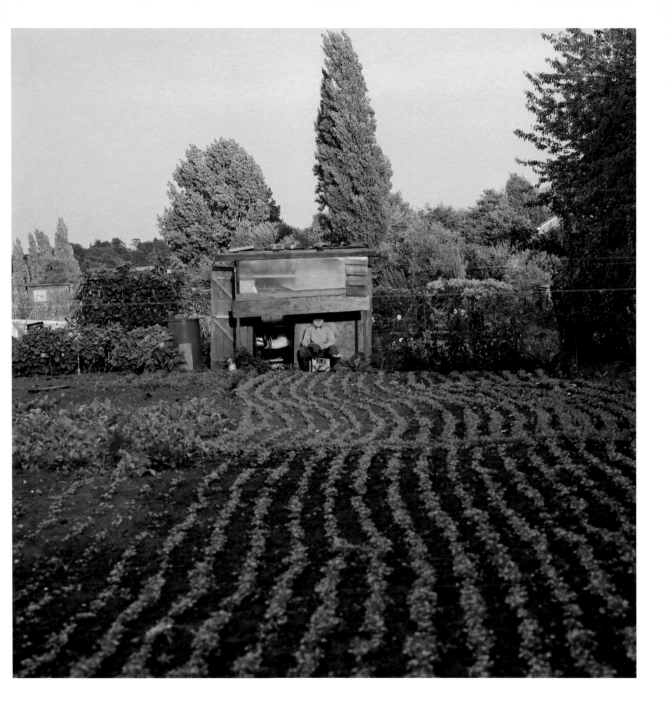

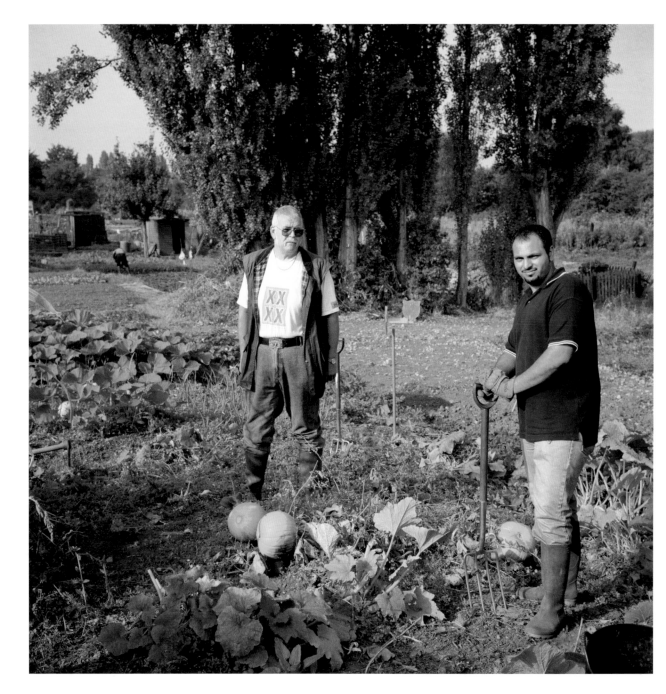

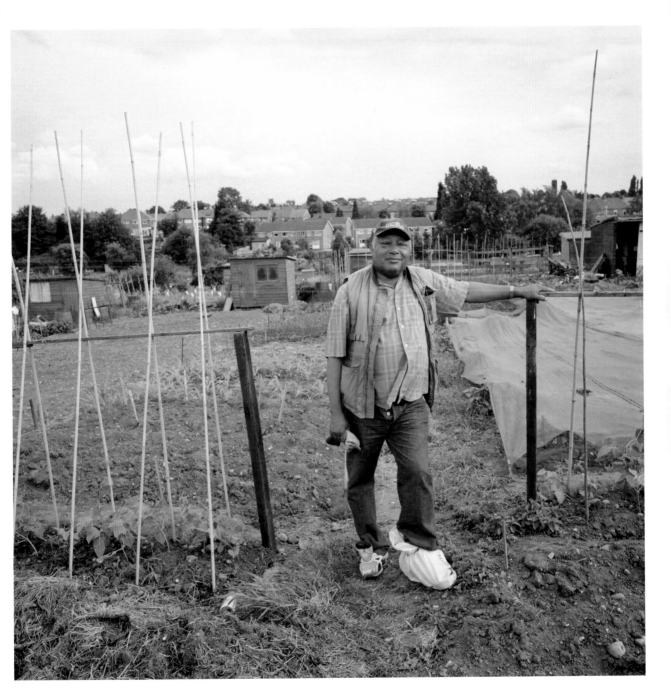

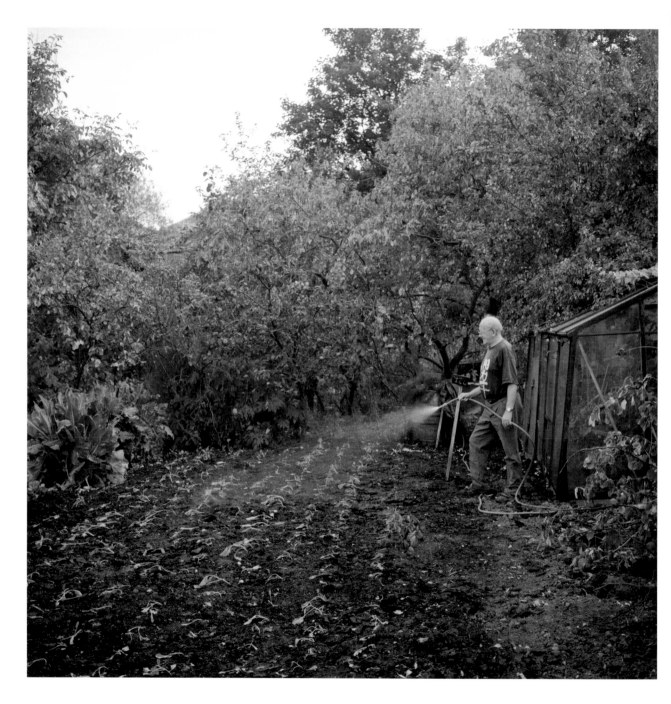

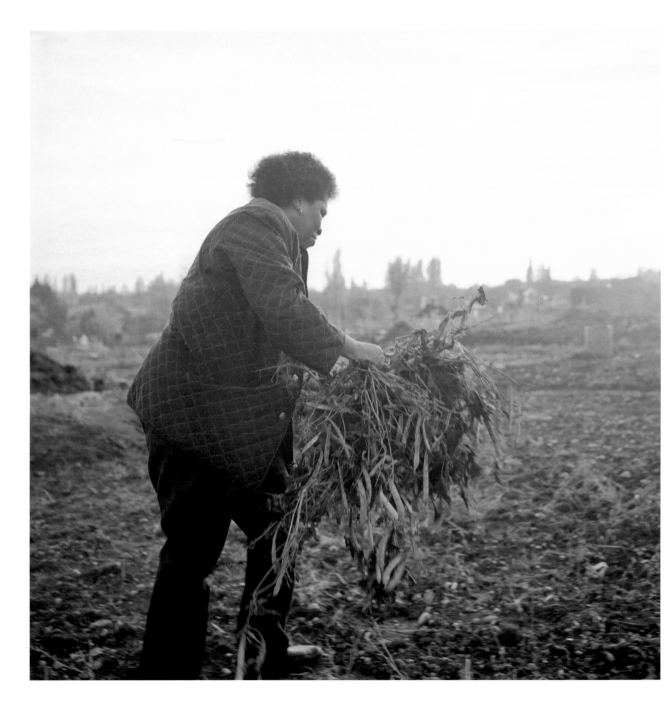

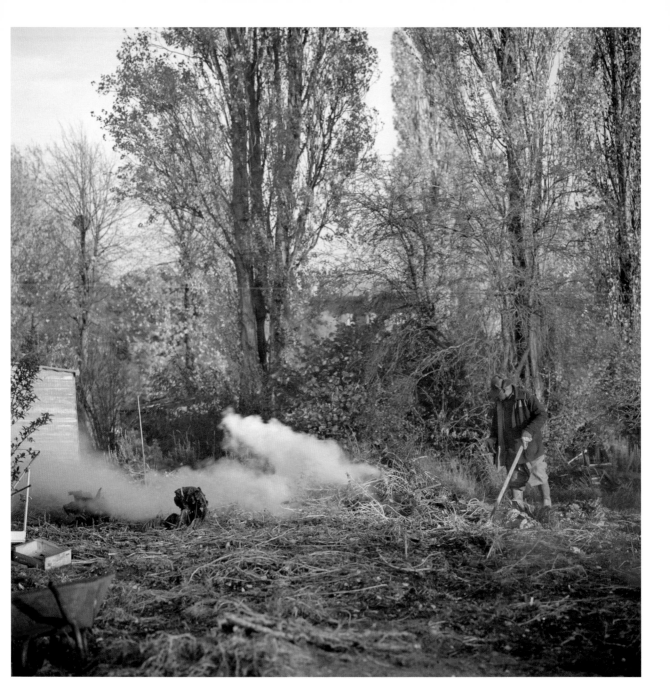

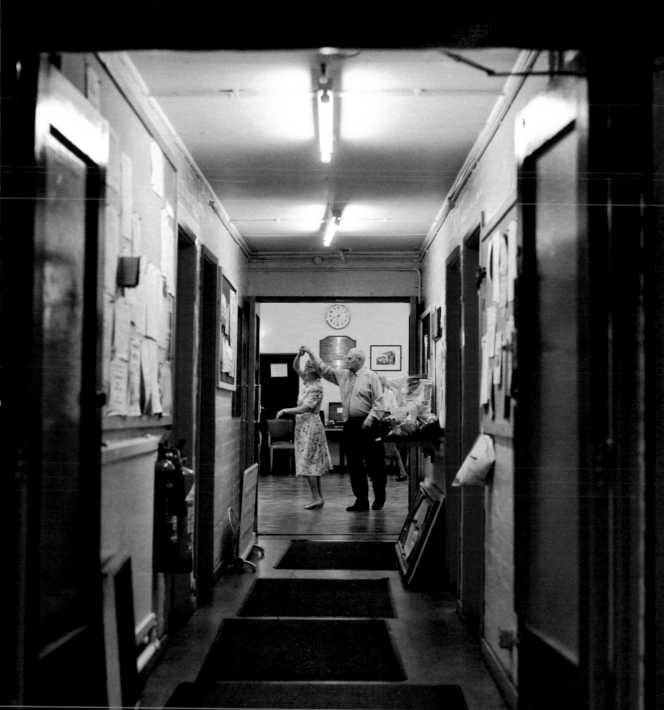
UPLANDS ALLOTMENT ASSOCIATION

Thank you to all at Uplands Allotments
who made sure I always left with photographs and great veg.

Thanks also to all who helped with the book especially
Urban Splash, Dewi Lewis, Paul Reardon, Dan Watkins,
Pete James, Simon Norfolk, Ed Clark,
Stephen Seddon and most importantly Neila Buurman